Dear Anna

Best Wishes

Brent

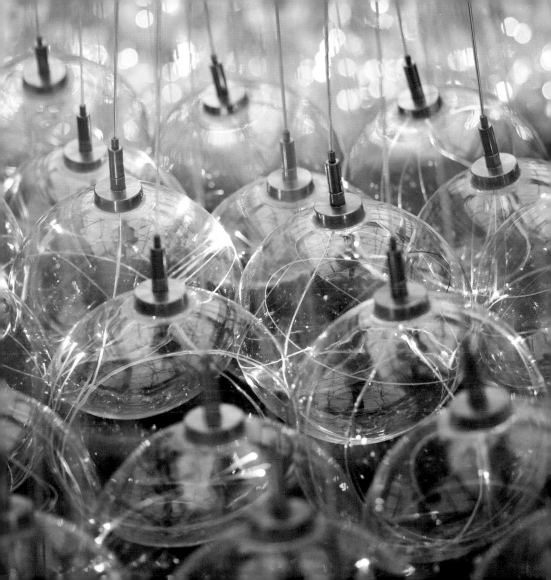

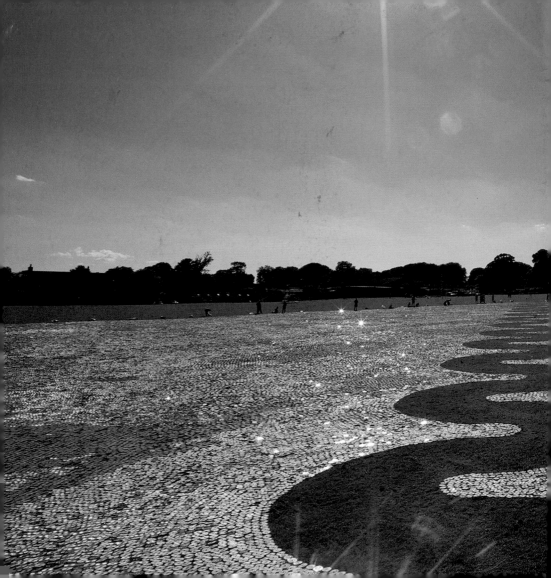

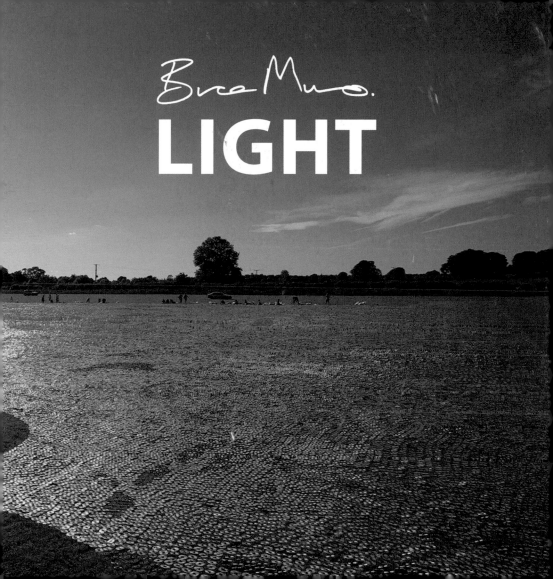

Bruce Munro, Long Knoll Field, Wiltshire, UK, 2010.

CATCHING THE LIGHT
DR. RICHARD CORK

With spectacular audacity, Bruce Munro succeeded in transforming a large English field with 600,000 unwanted compact discs. Given by donors across the world, these discarded CDs were given new life by a team of volunteers walking over Long Knoll Field in Wiltshire. They included families with children, all of whom helped to lay out the discs so deftly that they ended up creating a vast blanket of silver. It emphasized the immensity encompassed by this ambitious work, which Munro called *CDSea*. And once it was complete, the entire shimmering installation was open to everyone who roamed along the public footpath bisecting Long Knoll Field. Rather than viewing it at a respectful and alienating distance, local people were able to experience *CDSea* in a very direct, visceral way. They must have felt like swimmers, poised on the edge of a glinting ocean. The ancient solidity of the field was replaced by a water like alternative, and after its installation in June 2010, the summer sunshine often gave these discs an aura of intense optical vivacity.

In this respect, Munro was remaining true to the seminal experience which inspired *CDSea*. It happened in Australia, where he spent eight years after graduating from art school in Bristol. Munro made very little art during his Australian period, which commenced in 1984. But his subsequent work has benefited immeasurably from the stimulus provided by a few revelatory moments in the Antipodes. So far as *CDSea* was concerned, the epiphany occurred one Sunday afternoon when he escaped to Nielsen Park, a part of Sydney Harbour National Park, which provided

Over: Beacon on the Hill, *Long Knoll Field, Wiltshire, UK, 2013.*

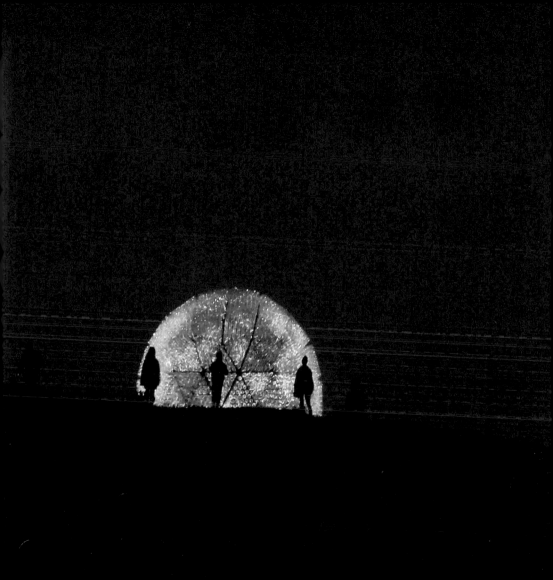

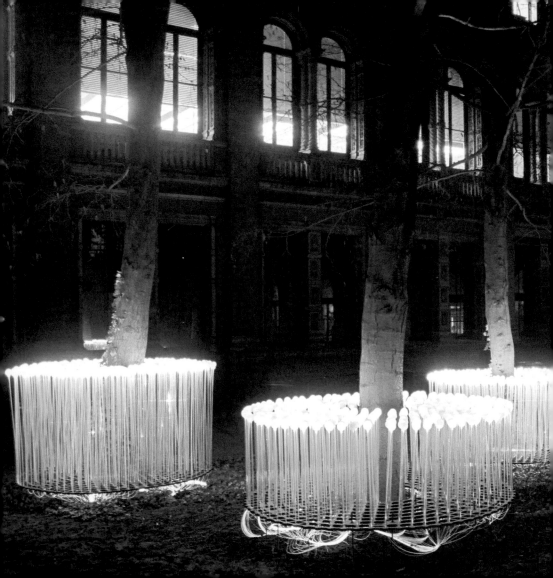

refuge from his weekday routine. Seated on a rocky peninsula, he gazed out to sea and found himself astonished by the sheer potency of the light. Munro's longing for England, and especially Salcombe in South Devon, where his father lived, was alleviated by the thought that the sun-saturated Sydney sea was linked, on a fundamental level, to the water lapping around Salcombe's coast. That is why Munro left Nielsen Park beach in a very positive mood, amazed that the play of light had changed his state of mind so profoundly. He now thinks that "it proved an unforgettable turning-point in my life."

Elsewhere, the irresistible power of Australian light would also nourish another of Munro's major sculptural installations. This time it happened in 1992 when he was journeying to Uluru through the barren red desert of central Australia. By a paradox, the extraordinary heat and brightness gave him a sustained energy. Every evening he would pull off the Stewart Highway and spend the night in a campsite. There, meditating quietly before sleep, Munro made on the pages of his ever-present sketchbook the first drawings for a work which has now undergone several fascinating permutations: *Field of Light*. As its title suggests, this installation comes alive at the onset of dusk. Suddenly, when the field grows dark and almost invisible, the stems of light which Munro planted there in thousands burst into bloom. He originally imagined them, during his epic 1992 expedition, flowering in the red desert as if nourished by a miraculous shower of rain.

During the first decade of the present century, when Munro's art reached maturity, *Field of Light* finally emerged in London. It made an arresting appearance in the *Brilliant!* exhibition at the Victoria & Albert Museum in summer 2004. And during the same year, a ten-acre version containing more than 15,000 individual stems of light was "planted" in Long Knoll Field. Through the seasons, he was able to scrutinise

Field of Light, *Victoria & Albert Museum, London, UK, 2004.*
Over: Field of Light, *Eden Project, Cornwall, UK, 2008–09.*

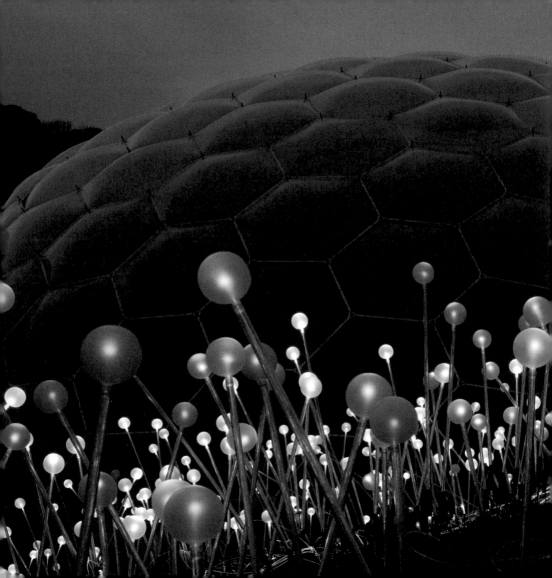

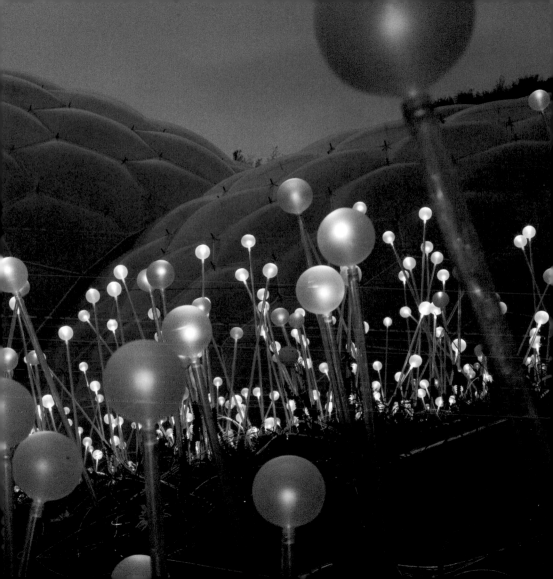

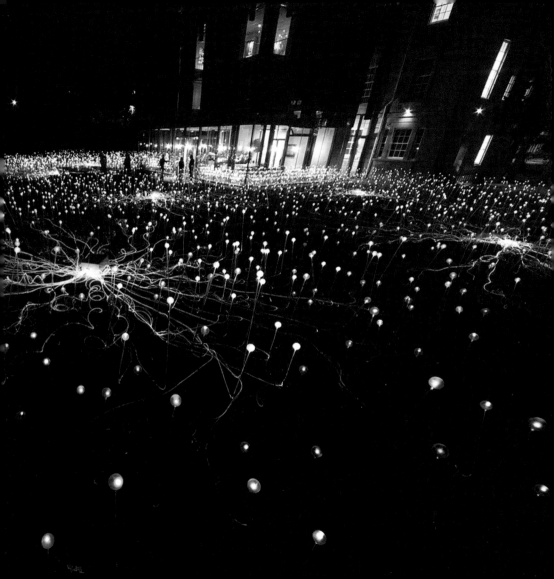

it from his nearby studio workshop until summer 2005, and thereafter Munro was given the opportunity to recreate *Field of Light* at the Eden Project in Cornwall. Here, between the Mediterranean and Rainforest "biomes," he installed 6,000 acrylic stems capped by frosted glass spheres. Laced with optic fibre, they were planted in the grass roof sheltering the visitors' centre. All through the Cornish winter of 2008–09, *Field of Light* provided an affirmative and, at times, revelatory spectacle for people who encountered it. And in 2011 Munro installed a 5,200-stem *Field of Light* behind the Holburne Museum in Bath, where a major extension had just been designed with great success by the architect Eric Parry. Munro is now hoping to take *Field of Light* back to its immense heartland at Uluru in central Australia, where no less than 250,000 stems illuminated by custom-made solar power projectors will be installed.

He has also been busy making pieces for landmark outdoor locations in the United States. Early in 2010 Munro was invited to create a solo exhibition for Longwood Gardens near Philadelphia, founded by Pierre S. du Pont. It opened two years later, and *Field of Light* played an important part in the show when it was spread across five acres of Longwood's Forest Walk to create *Forest of Light*. Subsequent exhibitions at Cheekwood Botanical Garden and Museum of Art in Nashville, Tennessee, and Franklin Park Conservatory and Botanical Gardens in Columbus, Ohio, were quickly proffered. At night, the garden visitors who discovered his sparkling assertion of multi-coloured growth and luminosity had no difficulty understanding why Munro once declared that "light is my passion."

The origins of this central obsession can be traced back to a very early stage in his development. Munro's parents split up when he was six years old, and subsequently he always looked forward to visiting his father down on the coast at Salcombe. The exceptional allure of the natural surroundings enthralled him, and he still remembers "when I was about eight walking from my father's house into Salcombe and

Field of Light, *Holburne Museum, Bath, UK, 2011.*

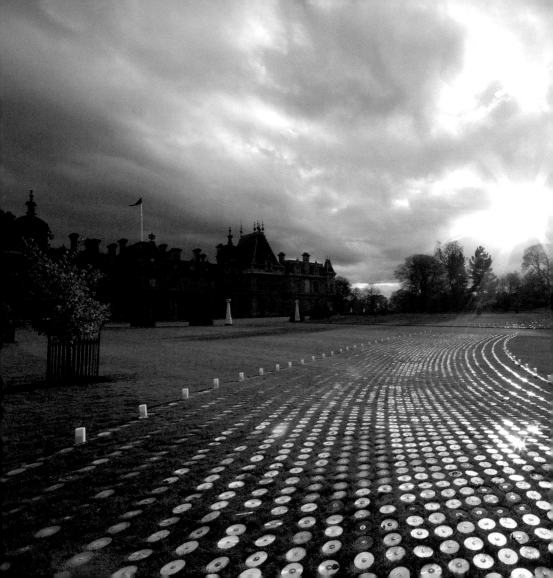

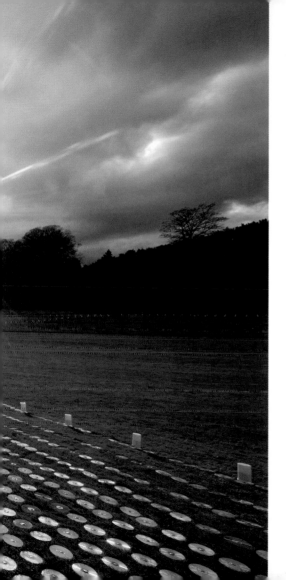

thinking: 'When is the secret going to be revealed?' Because I thought there was an essence which was mysterious." As a teenager, Munro got into trouble for his penchant for daydreaming, and he created his own private world in the pages of sketchbooks. Although they were often dismissed as mere escapism, the truth is that Munro's persistent dreams were all inspired by his alert, hungry response to the world around him. He recalls how "at the age of twenty-one, I was running down a path at home and smelling wild apricots on a beautiful autumn evening. Then I disappeared and felt as if I were floating across the ground. It was a magic moment, being at one with the world."

But he was not yet ready to give these visions a sculptural form. Munro had spent much of his adolescence trying to paint his nightly dreams, and he was haunted by "images of a shark in a pool, big waves, and a mushroom

Angel of Light, *Waddesdon Manor, Buckinghamshire, UK, 2012.*

15

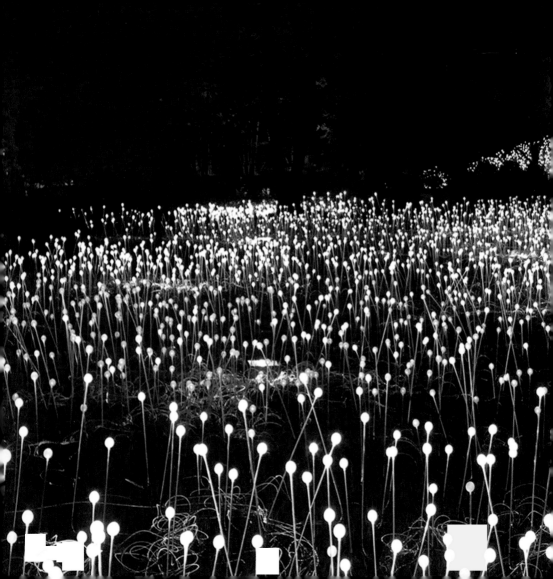

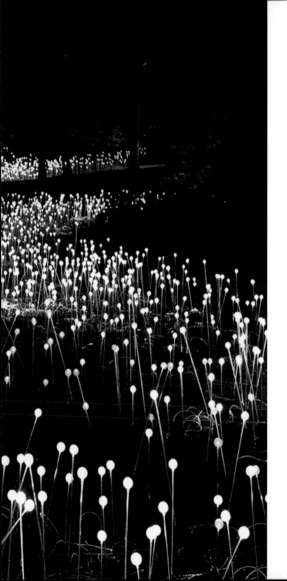

cloud." Although he is now pursuing some of these nightmarish images, they led him nowhere during his teen-age years. Even at art school Munro did not realise that sculpture was the prime area he should explore. Several painters commanded his particular respect as a student. He remembers admiring Matisse "because I felt he was so spiritual, and I adored Howard Hodgkin. I would love to make sculptures that have the feel of his paintings." Munro was also impressed by Georgia O'Keeffe's "beautifully haunting paintings," especially a large, late image of "clear blue sky populated by abstracted clouds that receded from the bottom to top edge of the canvas." Among the pioneering artists inspired by the land, he responded to James Turrell as well as Richard Long, who had started out studying at the same art school in Bristol. And Munro has never forgotten watching a mesmeric film of a road, *Last Chants for a Slow*

Field of Light, *Cheekwood Botanical Garden and Museum of Art, Tennessee, USA, 2013.* 17

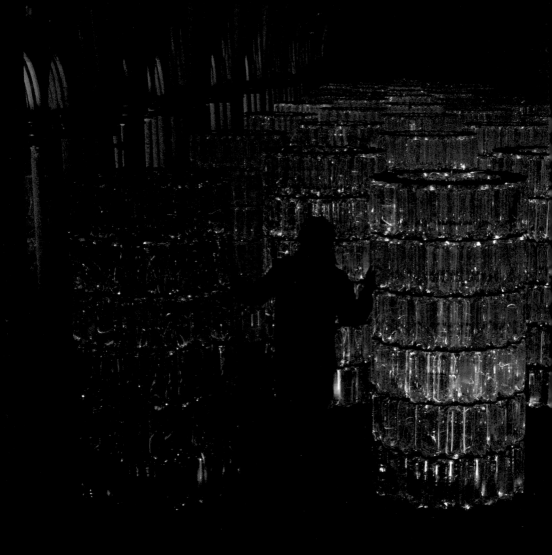

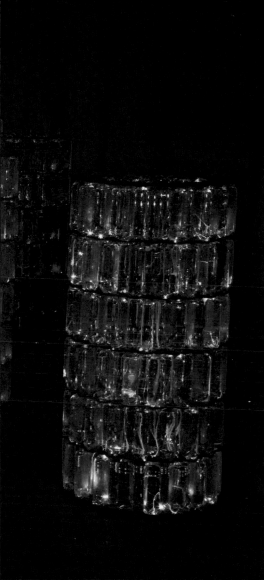

Dance, by the independent American filmmaker Jon Jost.

Book-reading likewise played a significant part in nourishing Munro's emergent imagination. Although he was "a late and slow reader, and never found it easy," his cousin brought books by C.S. Lewis to the family house. Munro's boyhood memories of the Narnia Chronicles were still alive enough in his mind to trigger a work called *Parliament of Owls*. His first thoughts for this piece were stimulated by a glass lens which reminded Munro of a caricatured owl's eye. But then he recalled that in *The Silver Chair*, of the Narnia Chronicles, a collection of owls was called a "parliament." Hence his decision to mount a whole collection of glass eyes on a telegraph pole which he had removed from the Long Knoll Field before burying the power lines underground. Munro always relishes finding new uses for discarded materials, and the

Water-Towers, *Salisbury Cathedral, Wiltshire, UK, 2010.*

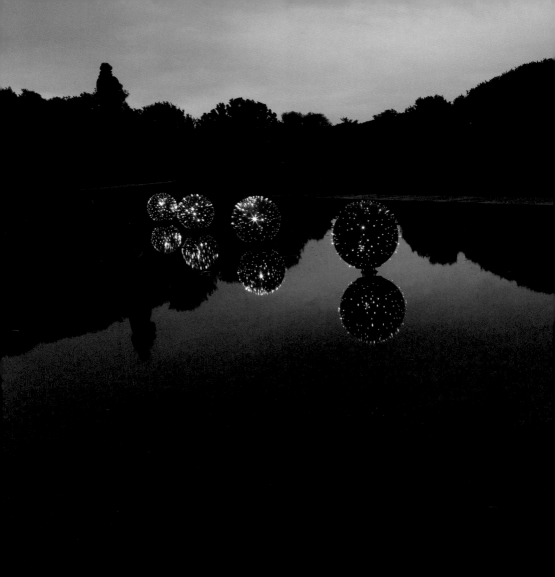

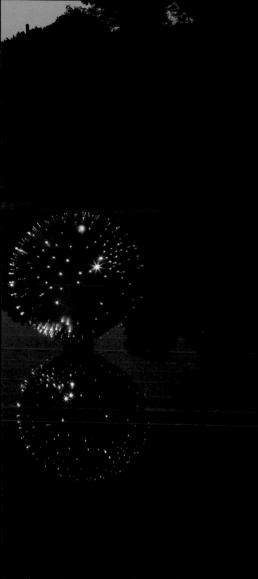

telegraph pole was triumphantly re-
stored to an upright position for its
new role in *Parliament of Owls*, finally
to be executed at Waddesdon Manor
in 2013.

Another important source of lit-
erary inspiration was Lyall Watson's
book *Gifts of Unknown Things*. Munro
read this radical text when he was
twenty-one, and became captivated
by the young girl Tia who lives on an
island in the Indonesian archipelago.
Very mysteriously, she can respond to
sounds by seeing them in colour. And
Tia's magical ability gave Munro the
crucial starting-point for an elaborate,
maze-like work called *Water-Towers*. In
2011 this dramatically illuminated se-
quence of 69 monumental structures,
each containing 252 recyclable water
bottles, was installed in the Cloisters
at Salisbury Cathedral, one of the most
aspirant Gothic buildings in Britain.
Munro stacked the bottles and lit them
with optic fibres, which responded to

Fagin's Urchins, *Cheekwood Botanical Garden
and Museum of Art, Tennessee, USA, 2013.* 21

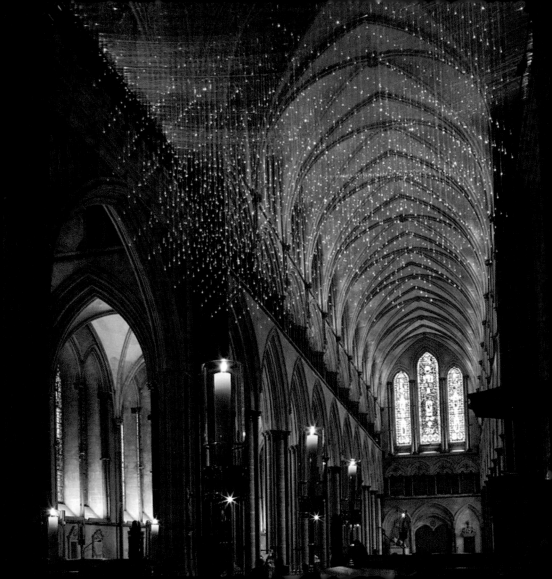

the sound of choral music. Visitors were invited to make their way through this dazzling maze and found themselves caught up in the synchronised rainbow of colours. They irradiated the people as well as the architecture, while inside the Cathedral a breathtaking *Light Shower* installation cascaded from the Spire Crossing. Munro succeeded in transforming the place where the transepts intersect with the nave, sending no less than 2,000 optic fibres floating downwards before they terminated in clear diffusers shaped like teardrops. The piece was illuminated to herald the beginning of Advent, when a candle-lit procession moved through the Cathedral celebrating the significance of the Advent Procession "From Darkness to Light."

By no means are all Munro's recent works as affirmative in mood. Like everyone, he has been affected by the pessimism and fear plaguing a Western world still shaken by military aggression and, above all, economic gloom. In a project for the future called *Last Charge*, he brings together 600 wooden clothes horses with 3,365 fencers and 6,730 discarded fluorescent tubes to create an outdoor area of stroboscopic light. Its flashing urgency evokes the appalling tragedy of the Light Brigade's futile charge in the battle of Balaclava. Lord Cardigan led this doomed cavalry assault during the Crimean War of 1854, and Munro's soundtrack of thundering hooves encourages everyone to visualise the riders hurtling to their tragic destination. Seen in its entirety, *Last Charge* looks like a flickering graveyard of fallen hopes.

An even more ominous future project is *The Last Wave*, a traumatic image which can be traced back to Peter Weir's film of the same name. Munro saw it on BBC television in 1984, just before he left his native country and moved to Australia. Eight years later, while making a farewell trip around Australia with his fiancée, Serena, Munro was still so haunted by memories of the film that he dreamed about a tsunami-like wall of water curving high over Sydney. Now he is determined to recreate its impact, using 2.5 million black mussel-shell casts suspended in mid-air and glowing with

Light Shower, *Salisbury Cathedral, Wiltshire, UK, 2010.* 23

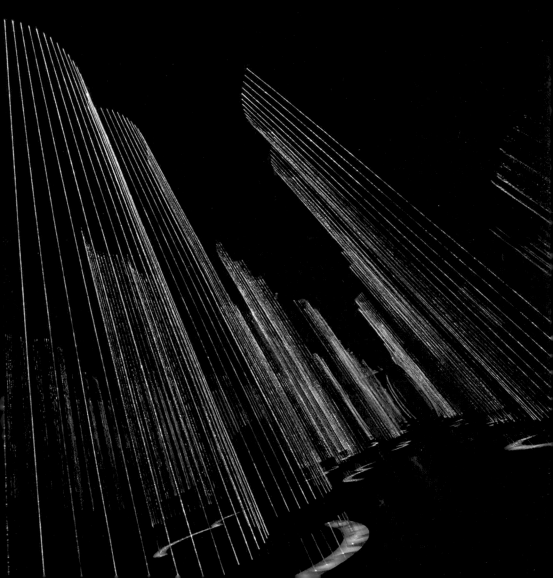

fibre-optic cables. This looming apparition would clearly be an unnerving spectacle, and sum up the apocalyptic anxieties which often invade twenty-first-century consciousness today.

Ultimately, however, Munro is sustained by an obstinate and fundamental spirit of optimism. At Waddesdon Manor, the magnificent property built in Buckinghamshire by Baron Ferdinand de Rothschild, Munro has made an evocative installation in 2013 called *Cantus Arcticus*. Music once again played a major role in bringing this work to the forefront of Munro's imagination. He heard on the radio a symphony with this title by the Finnish composer Einohujani Rautavaara. Its sublime soundscape captivated him, and after downloading a copy of the music, he listened to it time and again. Such obsessive concentration led Munro to create, for the capacious interior of Waddesdon's Coach House at the Stables, an evocation of the Northern Lights and the frozen landscape of the Arctic tundra. Abstracted forms inspired by seabirds can be found here, suspended in a space where curtains of fibre-optic strands are fortified by steel cone bells. Veils of light cascading from above create an all-pervasive luminosity and cast soft pools of colour which alter in response to the unfolding drama of Rautavaara's symphony. *Cantus Arcticus* testifies to the enduring power of music in Munro's current work, but he also regards the Waddesdon installation as an act of homage to Kama, the Hindu god of love. Munro is convinced that Rautavaara's music is "a holistic interpretation of the beauty and wonder of life itself, in this instance the lives of humans and birds."

After the death of Munro's father in 1999, Munro suffered a crisis and then benefited from the healing power of meditation. It enabled him to realise the importance of focusing above all on being at one with the world, and this sense of unity finally helped him to develop his mature vision as an artist. Although most of his outdoor works are temporary, one of his most ambitious projects centres on the creation of

Cantus Arcticus, *Waddesdon Manor, Buckinghamshire, UK, 2013.*

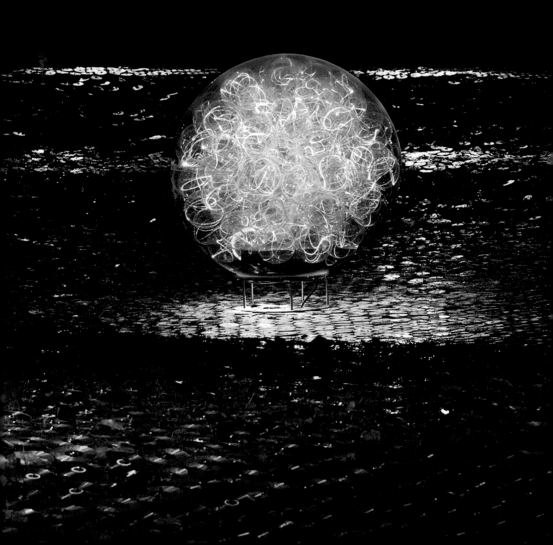

a building called *Mettabhavana*. It originated in a Barbados beachside house, where he was staying with his family in 1997. On the first night, Munro dreamed that he saw a mysterious building from which light softly emanated, generating an aura of peacefulness. Now he has completed the design of just such an elemental structure, reassuring in mood and accompanied on all sides by water in elliptical pools. During the day this building will be illuminated by the sun, and at night by beeswax candles. He sees it essentially as a place where Metta Bhavana, the loving-kindness meditation, can be practised by everyone who enters its calm, luminous interior.

While riding his bicycle in 2009, Munro remembered the undulating pathway in *CDSea* and realised that it linked up with the spiritual river which appears in two of the books he most admires. In *Kim*, Rudyard Kipling describes an arrow passing "far beyond sight" before falling and creating a river of limitless beneficence. In the other book, *Siddhartha* by Herman Hesse, "The river looked at him with a thousand eyes: green ones, white ones, crystal ones, sky-blue ones." It sounds uncannily like a description of Munro's glinting installations, and when Siddhartha "listened attentively to the thousandfold song of the river . . . to all of them, the whole, when he perceived the unity," then at last he "ceased to struggle with fate, ceased to suffer. On his face bloomed the cheerfulness of wisdom that is no longer opposed by will, that knows perfection, that is in harmony with the river of what is, with the current of life." Of all the connections across music, science, and literature which feed Munro's multi-faceted art, these heartfelt words sum up the essence of his vision with disarming eloquence.

Blue Moon on a Platter, *Waddesdon Manor, Buckinghamshire, UK, 2012.*
Over: Fireflies, Cheekwood *Botanical Garden and Museum of Art, Tennessee, USA, 2013.*

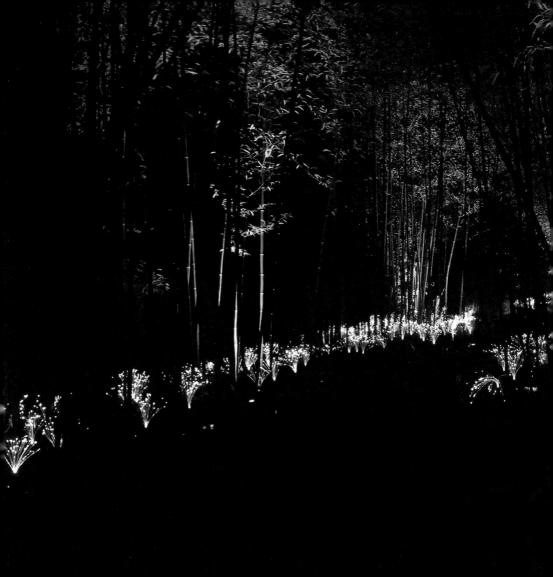

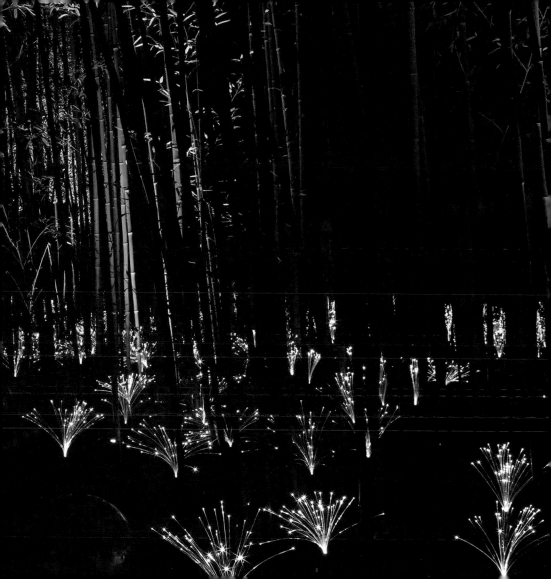

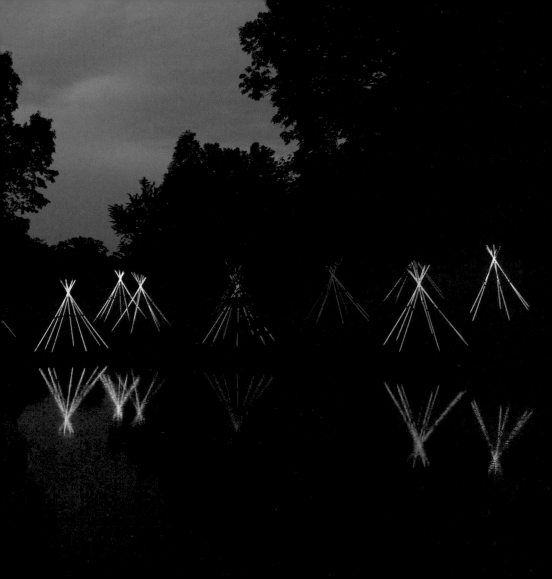

INSPIRATIONS
BRUCE MUNRO

I discovered light as a medium first in my professional career, outside of fine art. I had studied painting during my school and degree education in Britain, but I needed to earn a living and found myself doing that in Australia, manufacturing display signs using a glowing ultraviolet plastic whose properties I loved. When I decided to work in light, I chose it very carefully because I knew I needed some kind of focus. I thought that working in a medium that was very pure and true would simplify my ability to express all the different ideas that filled my head.

At first, the light things I was making were really lighting design. Then in my early forties, I began making things that were personal. I realised that I had always been striving to be so different—to make my art different—but starting then, I began looking for shared experience. Our experiences of being connected to the world in its largest sense, of being part of an essential pattern, became my subject matter.

Of the artworks I've had the privilege to make so far, *Field of Light, CDSea,* and *Water-Towers* have come most purely from moments of crystallised consciousness, memories of feelings that stood out so strongly that, years later, I could clearly put my finger on that emotional spot. Other pieces, like *Light Shower,* are a response to a particular space, and the opportunity to develop a component that will create the effect that I want. More and more, as I am offered the opportunity to consider specific sites, those two urges connect, and the artwork becomes about both the memory and the space. I have so many more pieces I can't wait to make.

Tepees, *Cheekwood Botanical Garden and Museum of Art, Tennessee, USA, 2013.*

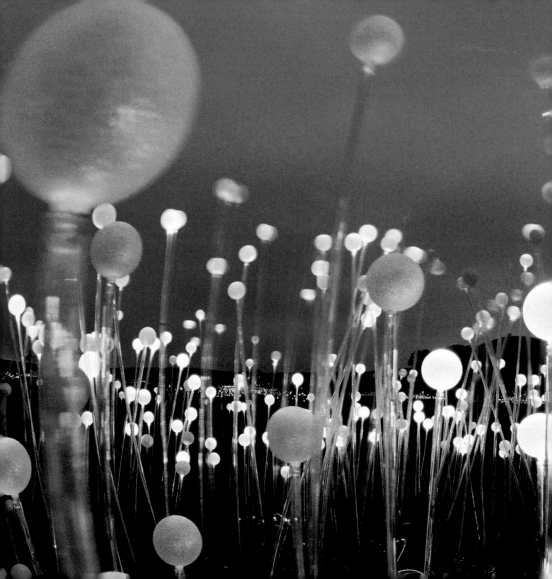

FIELD OF LIGHT

The *Field of Light* was originally conceived in 1992 during a trip through central Australia. The red desert had an incredible feeling of energy; ideas radiated from it along with the heat. The *Field of Light* installation was one idea that landed in my sketchbook and kept on nagging at me to be done.

The very first *Field of Light* was sown under the shadow of an ancient hill behind my home in southwest England in 2004. By placing an alien installation in the midst of nature, the enormous contrast created allows one to literally see the wood from the trees. One's attention is thus drawn to the nature that surrounds the installation as well as to the *Field of Light* itself. This contrast has always been an important focus since the idea germinated.

Laid out across a field of clover bisected by a public footpath, the first *Field of Light* shimmered its way through the seasons, presenting a myriad of opportunities for passersby to catch glimpses of the piece interacting with nature in all her guises. I am hopeful that every iteration of the *Field of Light* will inspire both young and old to take from it and create something of their own to pass on to others.

In recent years, I have had many more ideas about the meaning of the *Field of Light* and an equal number of ways to express these thoughts, but my instinct tells me that that is not what I am meant to do, other than say the *Field of Light* is a personal symbol for the good things in life. My job is to make it happen and inspire those around me to join the project. I hope that it will gather its own momentum, and like the proverbial snowball, take on a life of its own when it reaches critical mass.

Field of Light, *Long Knoll, Wiltshire, UK, 2004.*
Over: Field of Light, *Longwood Gardens, Pennsylvania, USA, 2012;*
Field of Light, *Cheekwood Botanical Garden and Museum of Art, Tennessee, USA, 2013;*
Field of Light, *Franklin Park Conservatory and Botanical Gardens, Ohio, USA, 2013.*

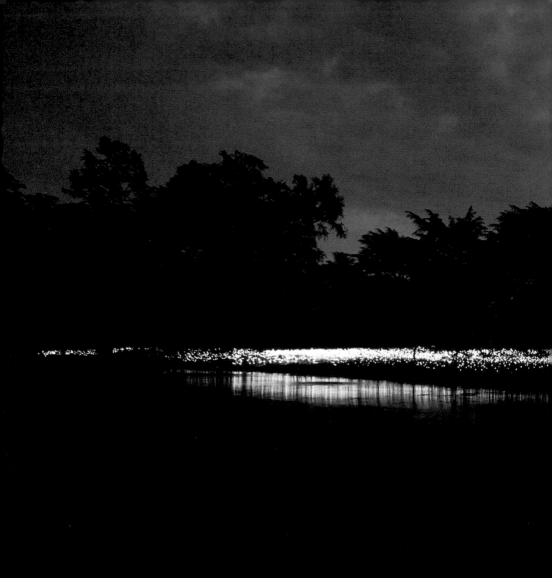

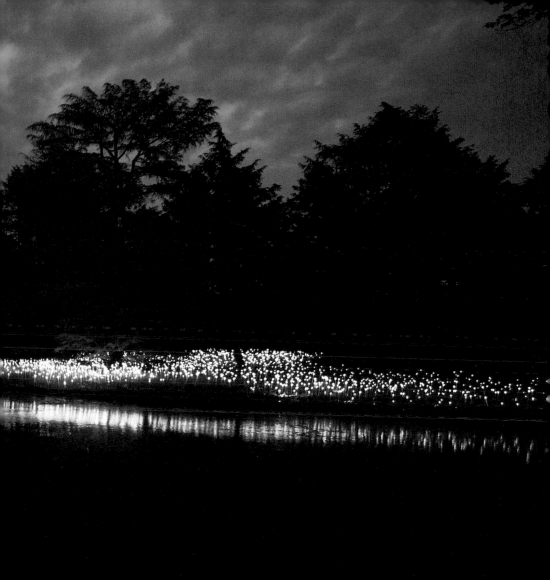

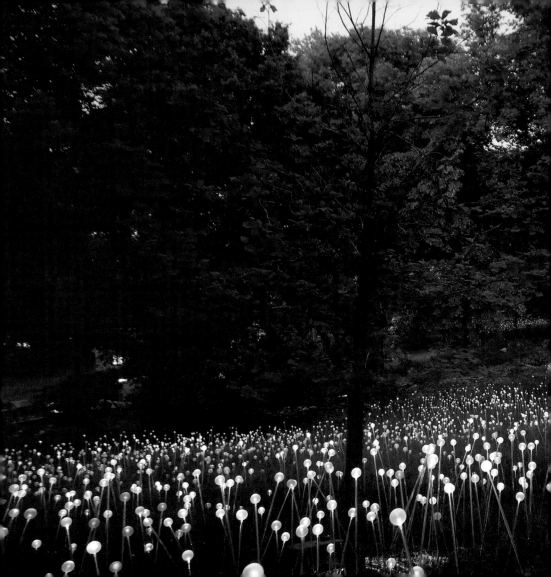

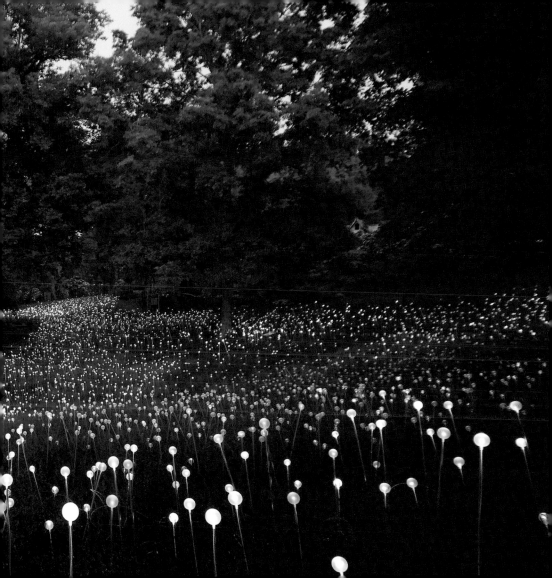

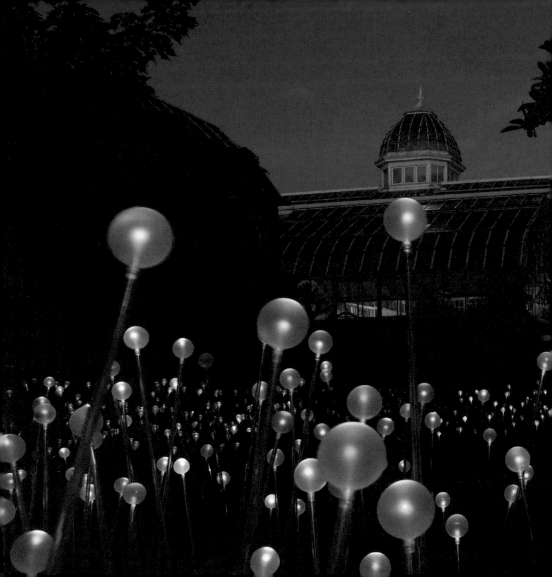

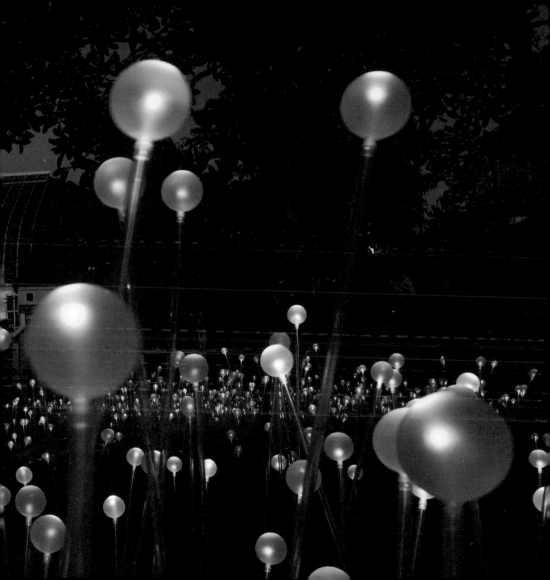

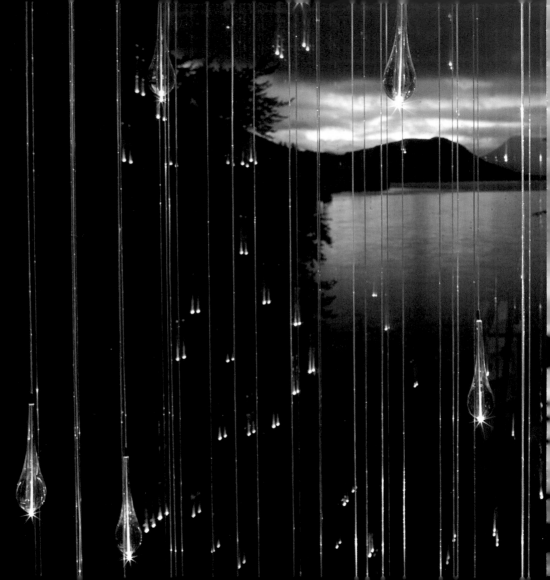

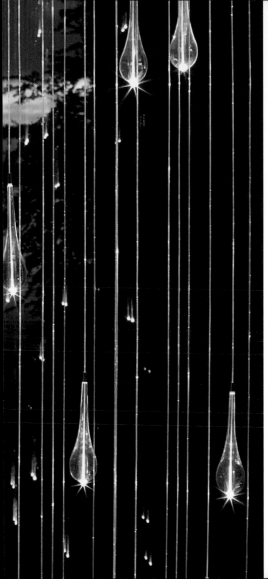

LIGHT SHOWER

In 2008 I was working on a design for a Highland lodge in Loch Ossian in Scotland. I found myself sitting on a step halfway up the main stairs of the lodge absorbing a magnificent, uninterrupted view of the loch and group of snow-capped mountains beyond. It was raining in squalls against the plate-glass window, which distorted the view with rivulets of water streaming down the panoramic pane. The words "light" and "shower" registered in my mind, and I had my idea.

The original installation now hangs motionless as if suspended in time, overlooking but not interrupting the view of Loch Ossian. By day it catches glimpses of the sunshine, shedding prismatic flecks of light onto the stairs; by night it morphs into what it is: a shower of light.

Light Shower, *Loch Ossian, Scotland, 2008.* 41

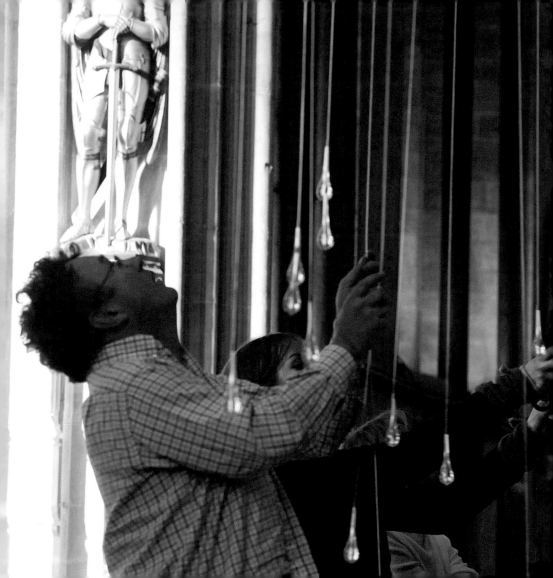

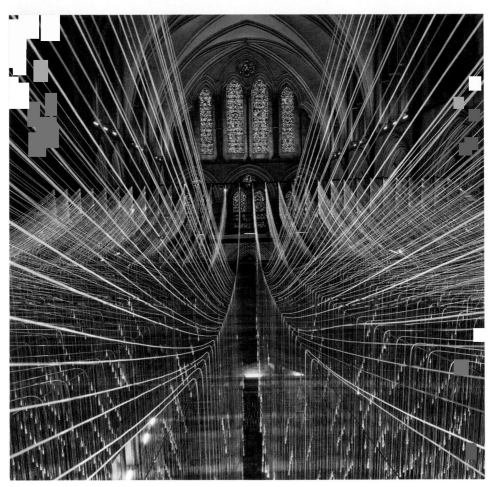

Opposite, above, and over: Light Shower, *Salisbury Cathedral, Wiltshire, UK, 2010.*
Pp. 46–47: Cheekwood Botanical Garden and Museum of Art, Tennessee, USA, 2013.

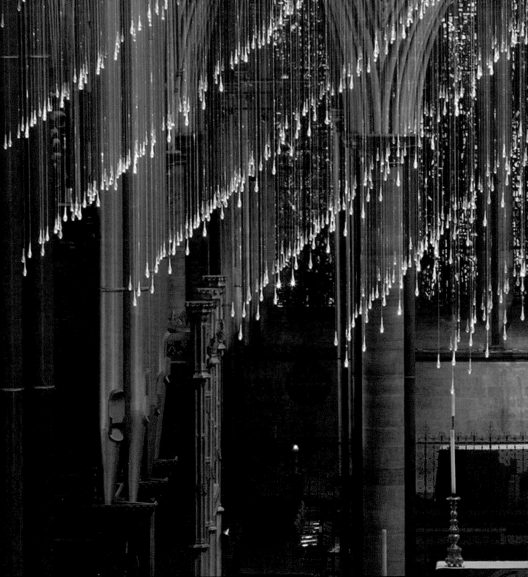

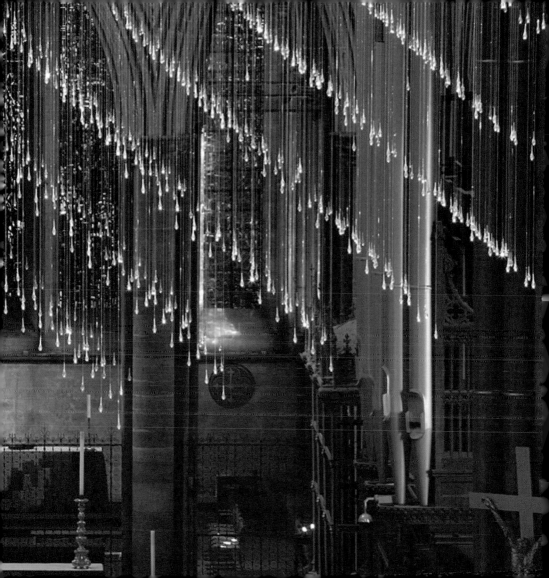

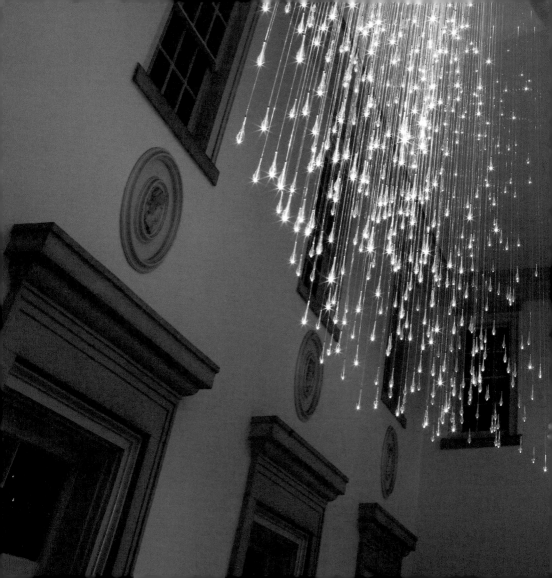

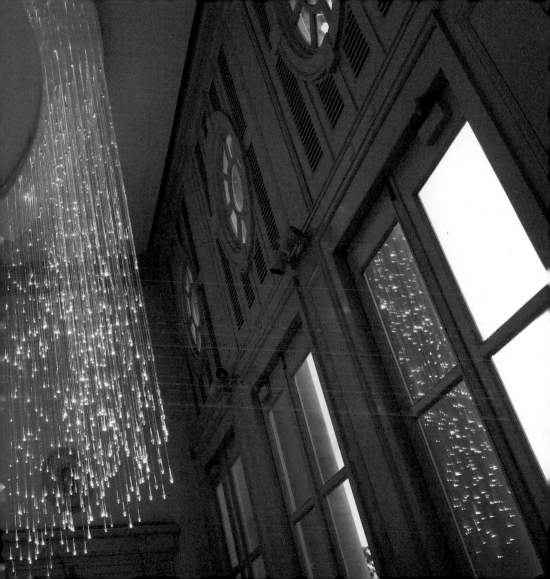

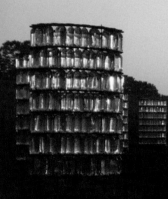

WATER-TOWERS

When I was twenty-one years old, I read a book called *Gifts of Unknown Things* by Lyall Watson, a radical thinker operating on the margins of accepted science. In it, Watson describes Tia, a young girl living on an island in the Indonesian archipelago who possesses the magical gift of seeing sounds in colour. Twenty-nine years later, Tia's gift inspired the design for a colourful, watery, musical maze.

The installation is an exercise in creating something magical from simple materials: PET plastic bottles, laser-cut wooden laminate, and water.

Watson described how the Earth has a natural pulse in the upper atmosphere, resonating at a rate of sixty-nine beats per day. The pulse forms a deep note well below human powers of hearing. This Earth pulse inspired *Water-Towers*, which originally consisted of sixty-nine towers; one for each pulse per day. Each tower is about two metres (six feet) tall and made from over 200 stacked water bottles illuminated by optic fibres. In their original formation, the towers resembled enormous liquid batteries of light arranged in a maze formation. Music emanates from the towers; the soundtrack reflects the musical diversity of many nations.

A control system scrolls through a rainbow of colours synchronised with the soundtrack. As the towers change colour, visitors experience sound magically translated into colour, just as Tia, Lyall Watson's heroine, does.

Opposite and over: Water-Towers, *Longwood Gardens, Pennsylvania, USA, 2012;*
Water-Towers, *Salisbury Cathedral, Wiltshire, UK, 2010;*
Water-Towers, *Cheekwood Botanical Garden and Museum of Art, Tennessee, USA, 2013.*

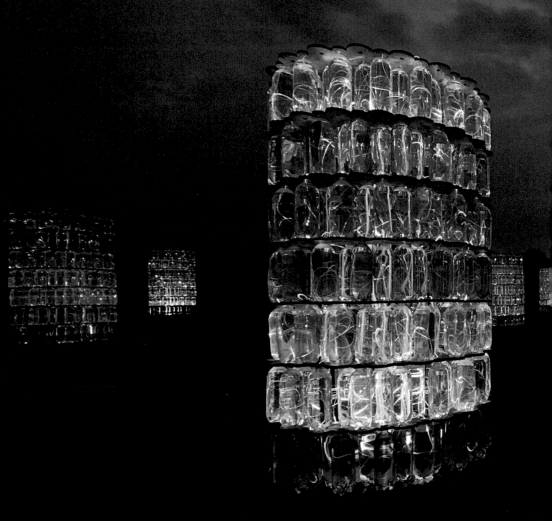

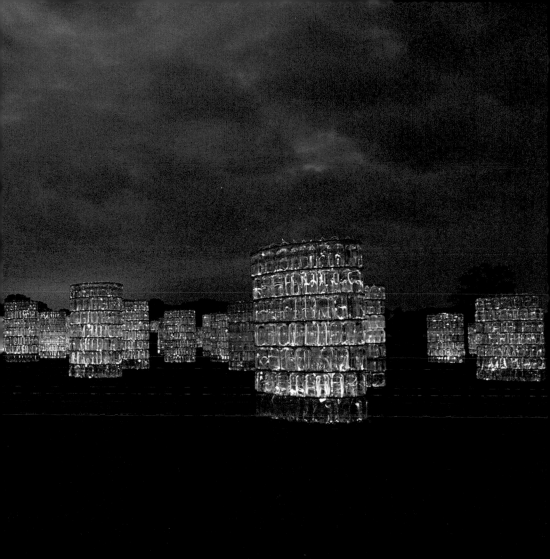

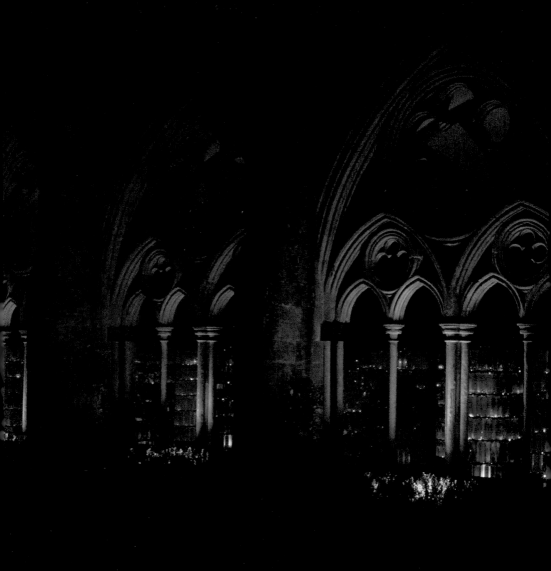

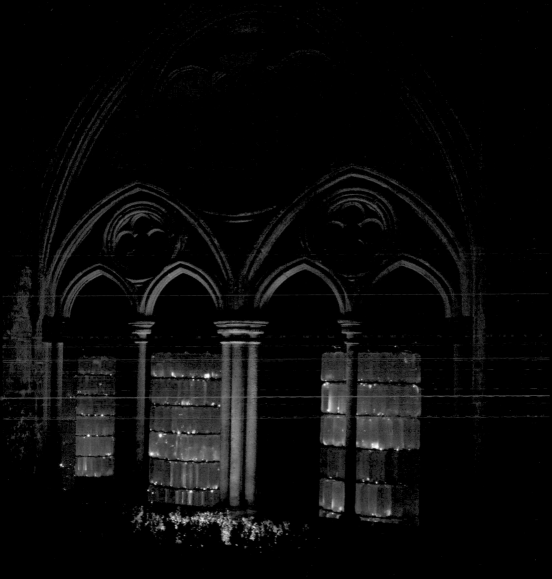

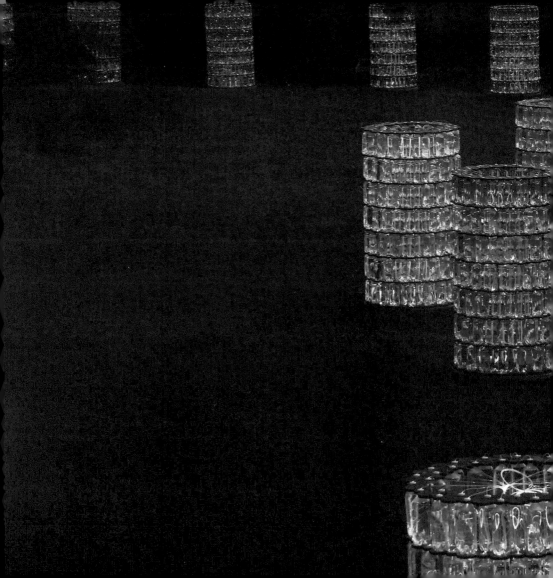

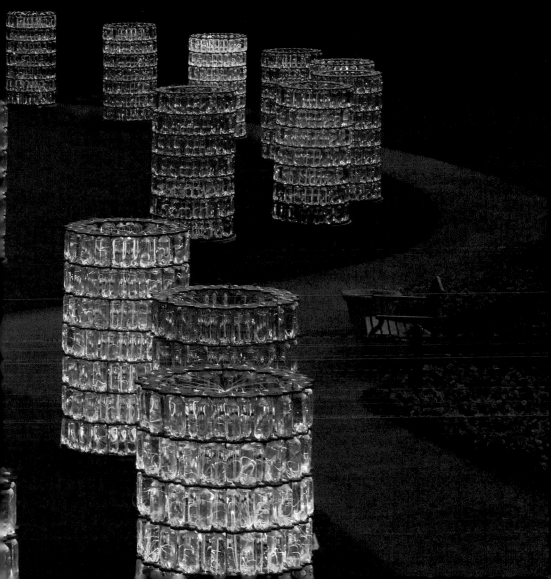

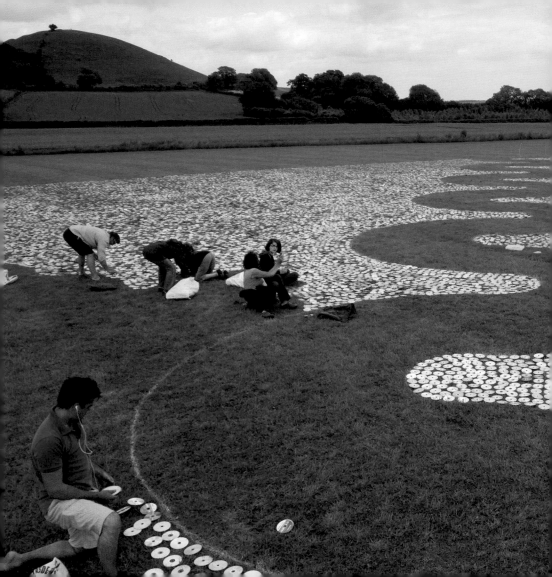

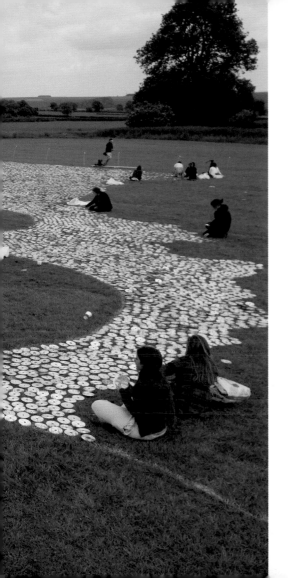

CDSEA

Entitled *CDSea*, this project was installed in June 2010 at Long Knoll Field in Wiltshire, where in 2004 we installed a prototype of the *Field of Light*. A public footpath intersects the field, and this meant that *CDSea* was on public view from the moment it was installed. Personal friends and family, including families with young children, all helped me and my team install *CDSea*.

CDSea is literally an inland sea created from 600,000 discarded compact discs, which were donated from all around the world. They created a carpet of glinting light, created by the reflections of the solstice sun. As with the *Field of Light*, the catalyst for *CDSea* was living in Australia, where eight years of exposure to the Antipodean sun left a lasting impression on me. *CDSea* was inspired one Sunday afternoon as I was sitting on a rocky peninsula at Nielsen Park, one of the beautiful Sydney Harbour beaches,

57

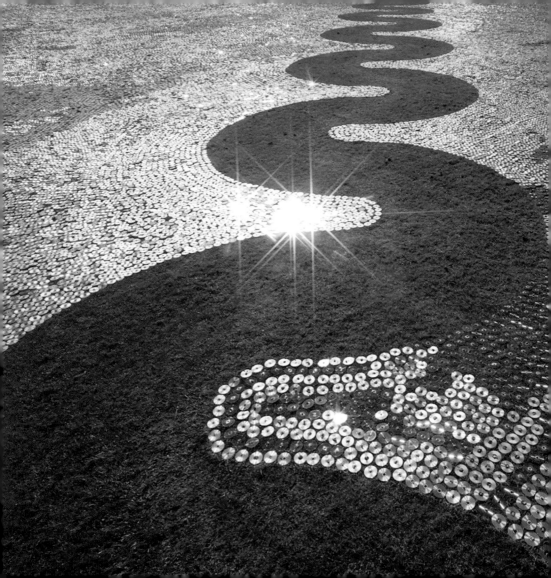

where I would go when I was a bit down or in the dumps. The light was still strong, like a blanket of shimmering silver light. I had this childish notion that by putting my hand in the sea I was somehow connected to my home in Salcombe, South Devon, where my father lived. I came away from the beach in a very positive at-one-with-the-world frame of mind. It was the first time I was aware that the play of light had transformed my mood, and it proved an unforgettable turning point in my life. I was astonished that something so familiar had the power to alter my emotional state. *CDSea* is a reconstruction of this event.

I do not expect visitors to feel exactly as I did, but I am certain that the materials, scale, and location, a field on top of a hill, will evoke emotions unique to each observer. If it inspires some smiling faces, then the emotional force has been successfully passed on.

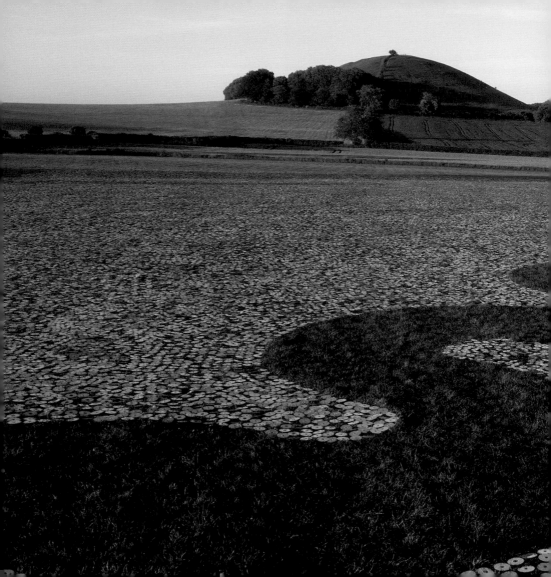

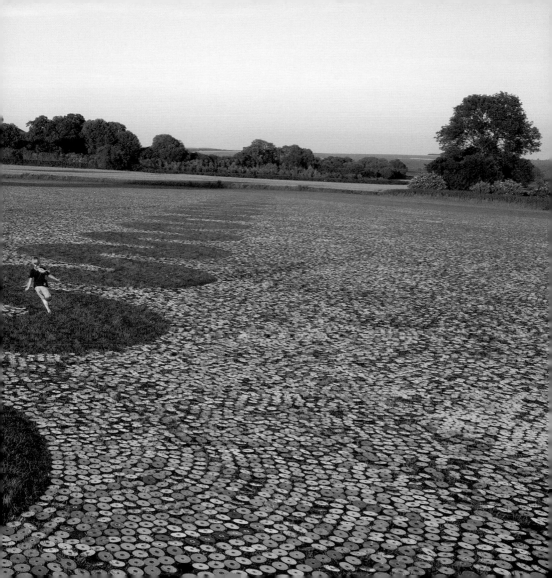

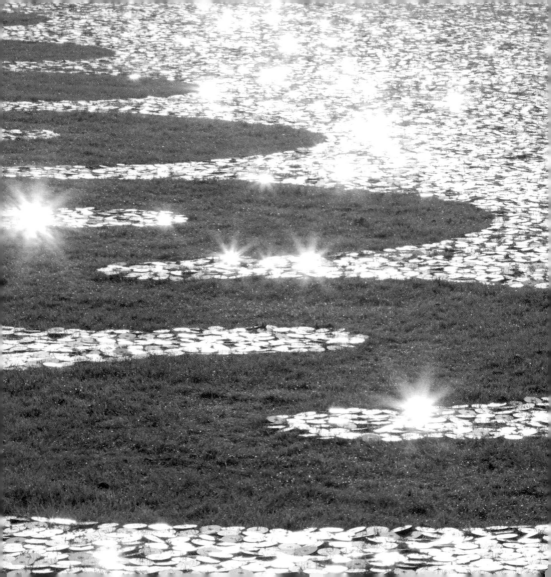

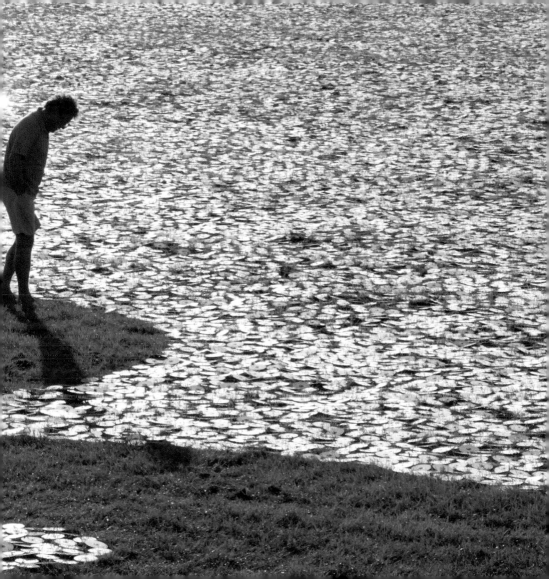

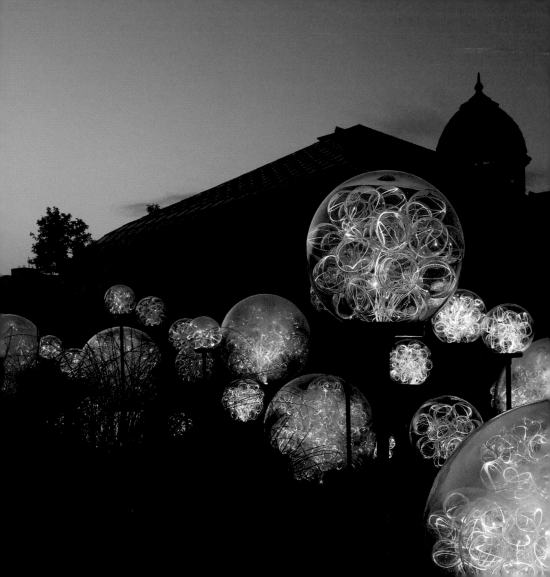

WHIZZ POPS

Twenty-eight years ago, an off-the-cuff remark about my sketchbook and my brain function cut me to the quick. A colleague casually said I had "a butterfly mind." The truth hurt, but it did galvanise me into addressing my cerebral shortcomings.

My solution was simple. To constrain, contain, create, and express my vivid imagination through the medium of light and let life take its course. Everything I have done since that enlightened day has had both a rhyme and a reason.

My sources of inspiration are many and varied, randomly alighted upon (butterflylike). It has taken me years to perfect my natural capacity for daydreaming into a conscious act. Certain pieces of work are connected by the materials I have to hand. At other times, two seemingly disparate ideas collide and make sense. Occasionally, it is a bit of both.

Whizz Pops was not created in a Eureka! moment. It happened because materials were by chance placed side by side in my studio, and they called out to each other. I took their name from the story *The BFG* by the writer Roald Dahl, whose books I had read to my children.

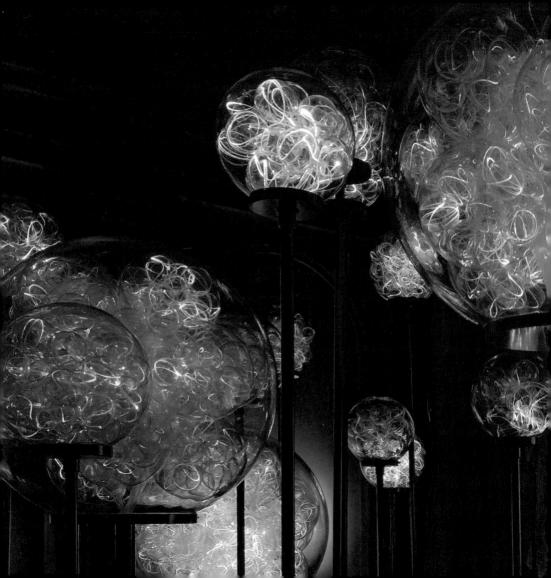

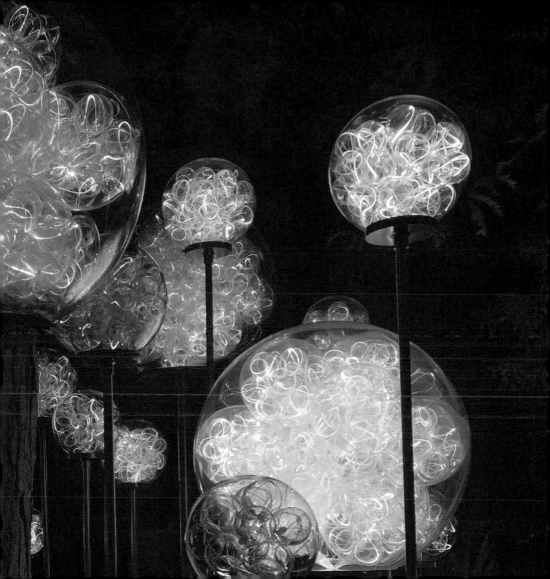

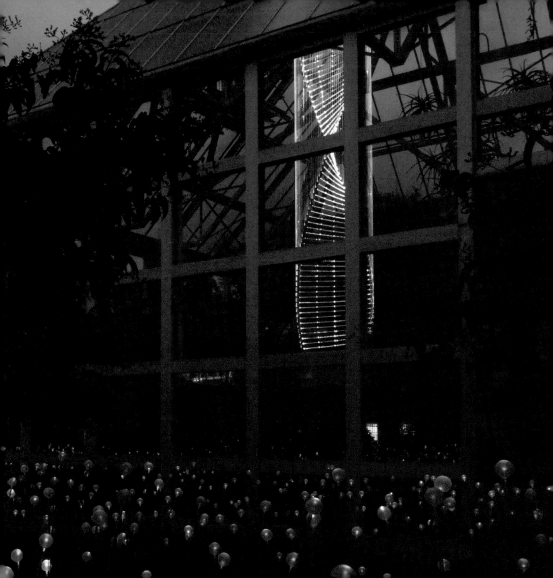

CHINDI

In September 2012 I was offered the opportunity to create an exhibition of my work for the Franklin Park Conservatory in Columbus, Ohio. The inspiration for *Chindi* came to me during my very first visit there. The area in question was the Desert Biome, a spaciously expansive zone, characterised by hot, dry air and a palette of sienna hues. Dust devils came into my mind, and I decided to give form to these ephemeral vortexes also called "chindi" by the Navajo.

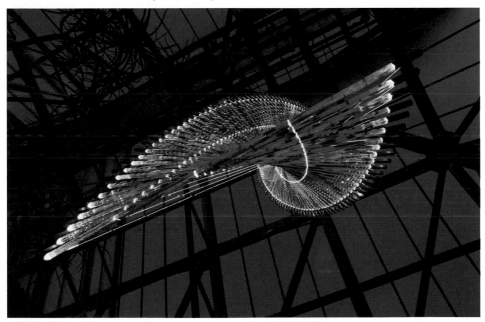

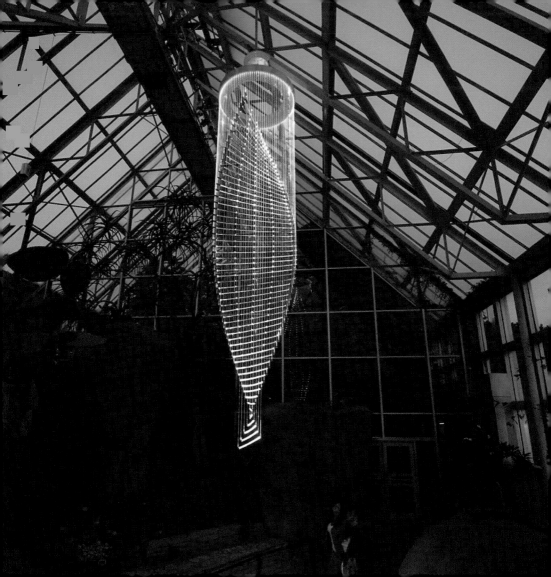

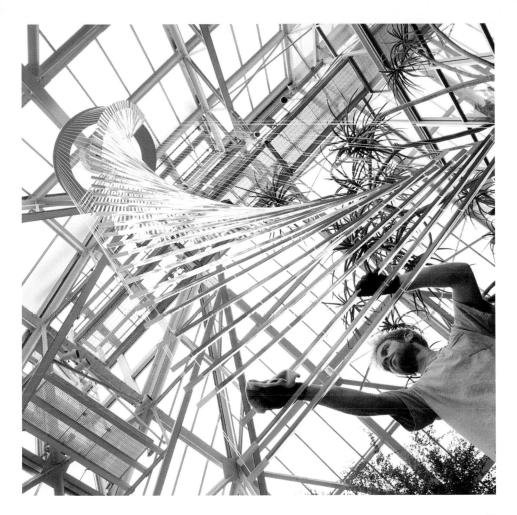

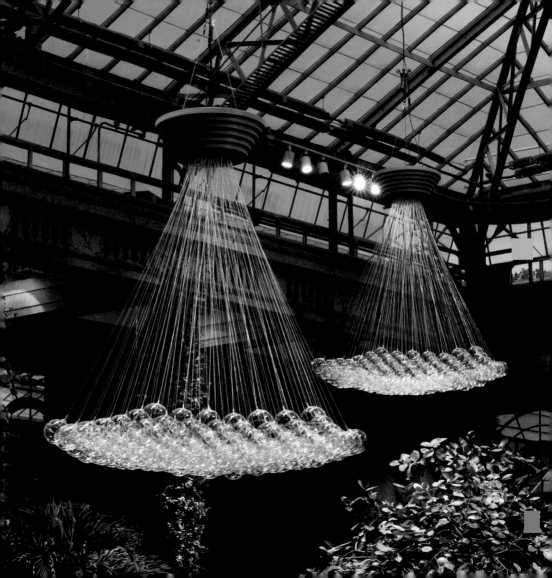

SNOWBALL

Stuck in a traffic jam, I saw a display of translucent Christmas baubles in a shop window. Next to me on the passenger seat of the car was optical fibre for another piece. I simply wondered how the balls would look all clustered together on the fibre harness, and so I hopped out of the car and bought all the stock in the shop! Back in the studio, I tore them apart and drilled them all out to accept a fibre-optic cable. This was laid across the back of my chair in the studio for a number of weeks, creating a canopy of opalescent spheres that winked like a gaggle of Cyclops' eyeballs. The reaction was very positive, so I then decided to develop them further, with spheres produced in glass.

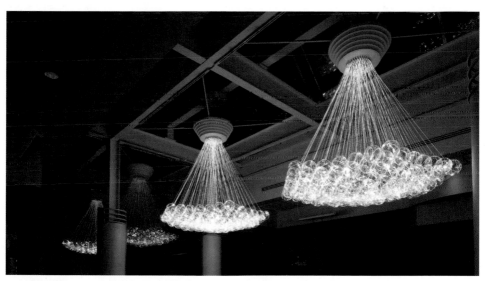

Opposite: Giant Snowballs, *Longwood Gardens, Pennsylvania, USA, 2012.*
Above: Giant Snowballs, *Franklin Park Conservatory and Botanical Gardens, Ohio, USA, 2013.* 73

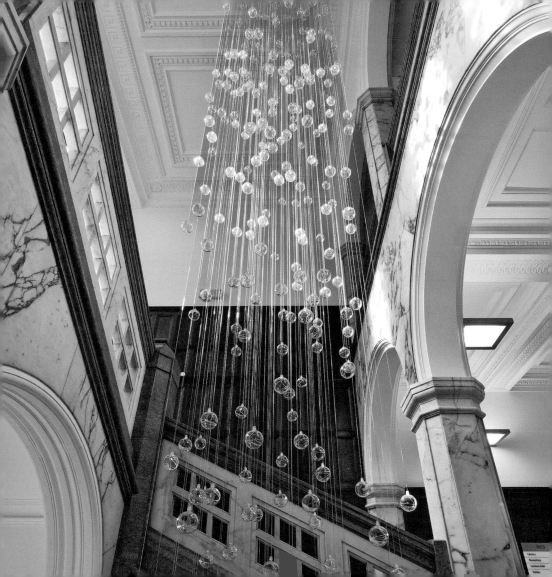

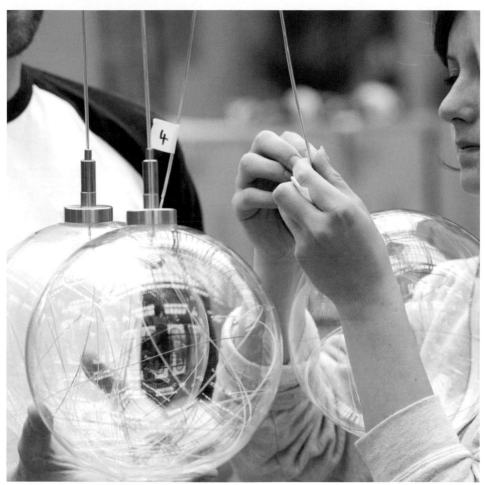

Opposite: Random Snowball, *Royal Institute of Chartered Surveyors, London, UK, 2009.*
Above: Snowball, *Longwood Gardens, Pennsylvania, USA, 2012.*

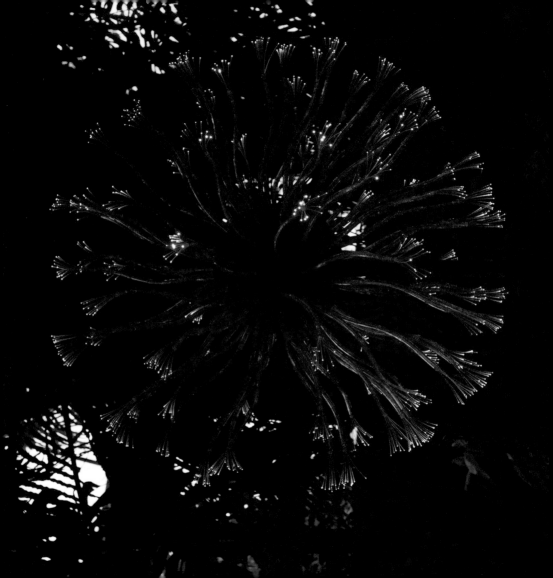

EDEN BLOOMS

Eden Blooms is a hybrid creation that has evolved from a number of design concepts. But it was during a visit to the Rainforest Biome of Franklin Park Conservatory that the idea of creating an exotic, illuminated bloom was formally sown. Each bloom is created from 91 serpentine-like arms radiating from a central core, with optical fibres ending in sprays of light to form a spherical seed head, meant to appear as if growing amongst the foliage.

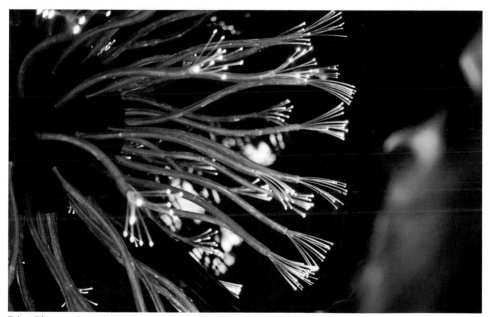

Eden Blooms, *Franklin Park Conservatory and Botanical Gardens, Ohio, USA, 2013.*

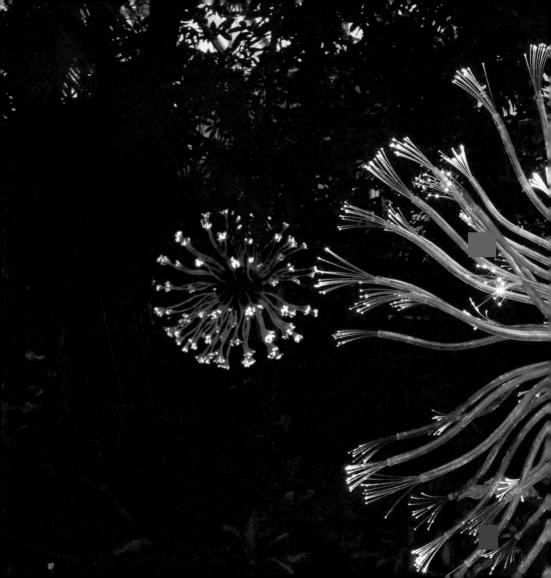

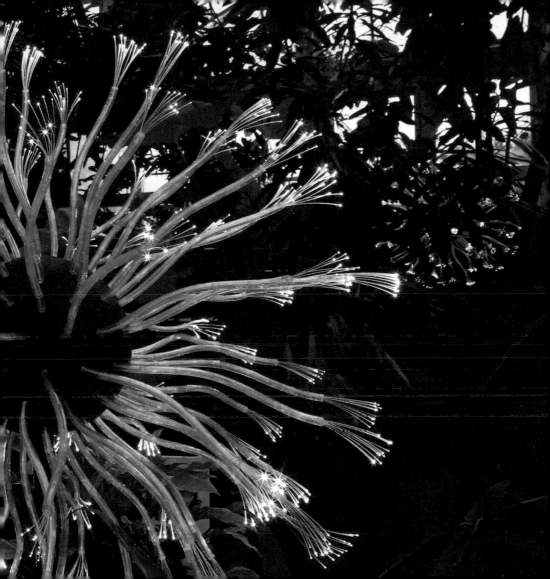

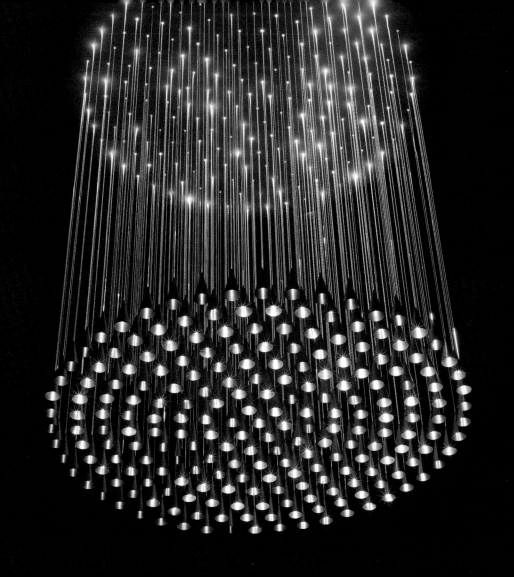

BELL CHANDELIER

Bell Chandelier is a Lilliputian canopy of conical shades and was created to simulate the function of the humble lampshade. Over the years I have learned that high spaces are made more comfortable by casting soft pools of light across a floor (without being blinded from above). By casting light, attention is shifted away from the luminaire itself. This indirect fibre optic lighting technique also allows one to stand back and appreciate both the sculptural whole as well as the individual components that constitute the piece.

The first iteration of the *Bell Chandelier* was created for the Lady Chapel, St James Church, in Barbados. An added bonus to this piece was added by the church's natural air conditioning system (gentle Caribbean breezes through an open window) which swayed the brass bells like a golden shoal of tropical fish.

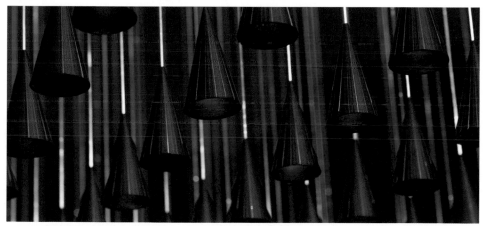

Opposite: Bell Chandelier, *St James Church, Holetown, Barbados, 2007.*
Above: private residence, London, UK, 2005.

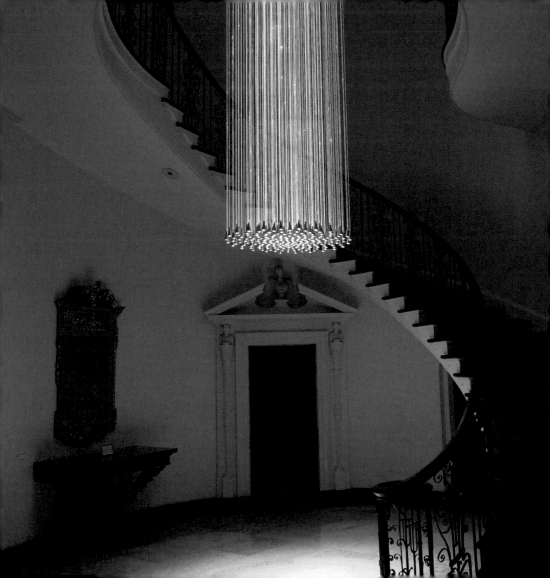

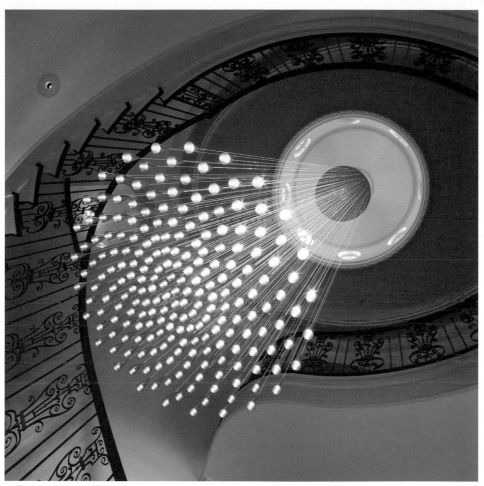

Bell Chandelier, *Cheekwood Botanical Garden and Museum of Art, Tennessee, USA, 2013.*

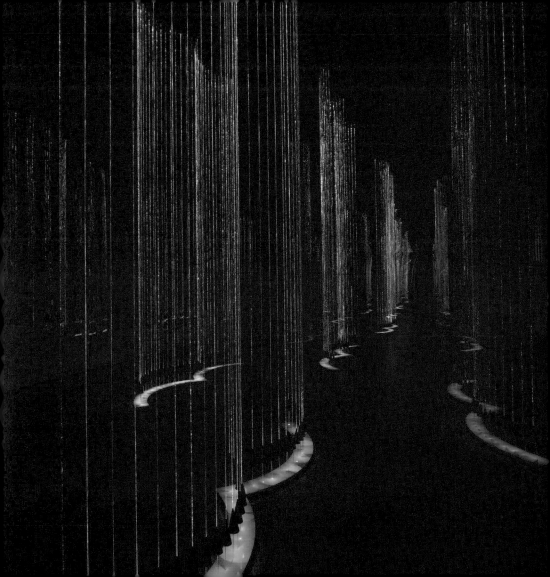

CANTUS ARCTICUS

The inspiration for this piece came from the music of Finnish composer Einojuhani Rautavaara. After the chance hearing of his music on BBC Radio 3, I listened over and over again to his concerto *Cantus Arcticus,* and requested his permission to create an artwork based upon it. I feel that Rautavaara's composition is a holistic interpretation of the beauty and wonder of life itself, in this instance, the lives of humans and birds. The sounds of Arctic birdsong interwoven with Rautavaara's orchestral score created a visual soundscape, which crystallised in my mind as shimmering curtains of light, suggesting the Aurora Borealis interspersed with the silhouettes of circling birds. For me, the first part of the concerto describes the human being as the observer. The latter part is about man's endeavour to describe the ephemeral experience and the simple truth that everything is connected. It is my hope that I have added to Rautavaara's genius with the addition of light.

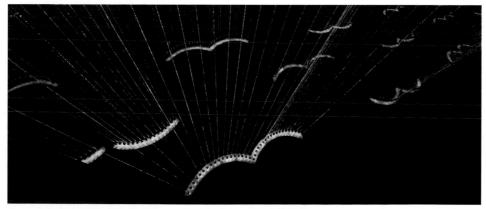

Cantus Arcticus, *Waddesdon Manor, Buckinghamshire, UK, 2013.*

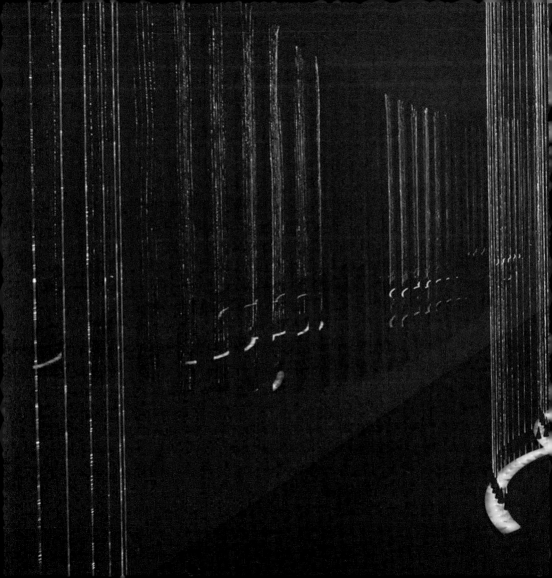

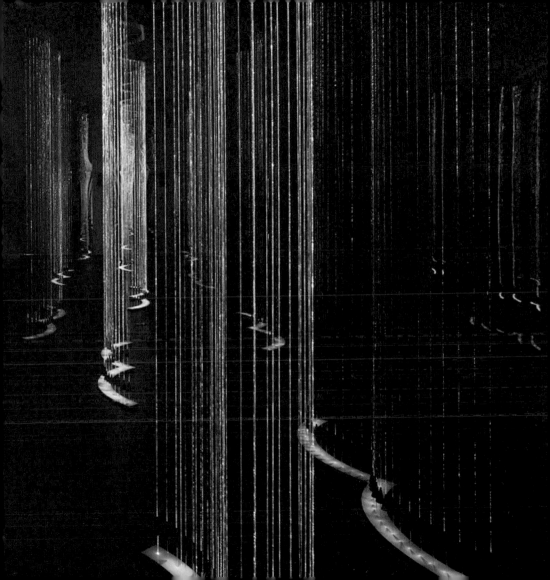

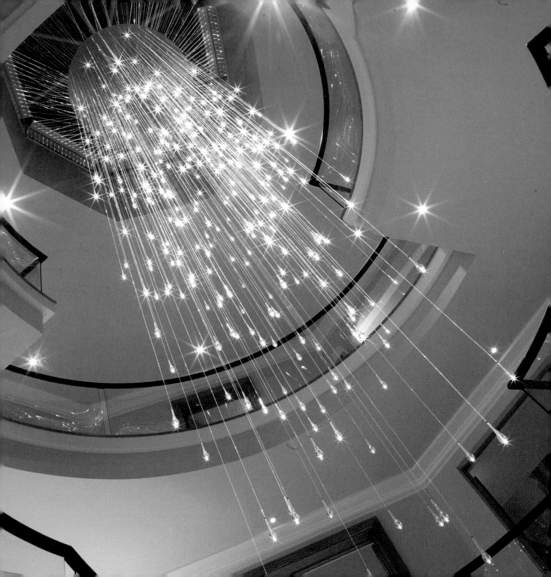

SUSPENDED LIGHT

To create commissioned pieces for private and public spaces is truly a great honour. Working with light for thirty years has taught me that seeing the space is where the journey starts. The scale, architectural form, and landscape are all canvas and more often than not inspiration. While searing light-bulb flashes of insight are wonderful, in reality, imagining a new artwork for a space is more often a connected process in which one draws upon experience, knowledge, and intuition.

Not knowing what one is going to do next can be very exciting (but somewhat nerve racking). But I guess it's what gets me out of bed in the morning and makes me realise I have the best job in the world!

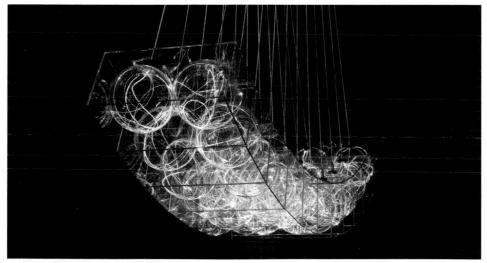

Opposite: Light Shower, *private residence, London, UK, 2009.*
Above: Swing Low, *private residence, London, UK, 2013.*

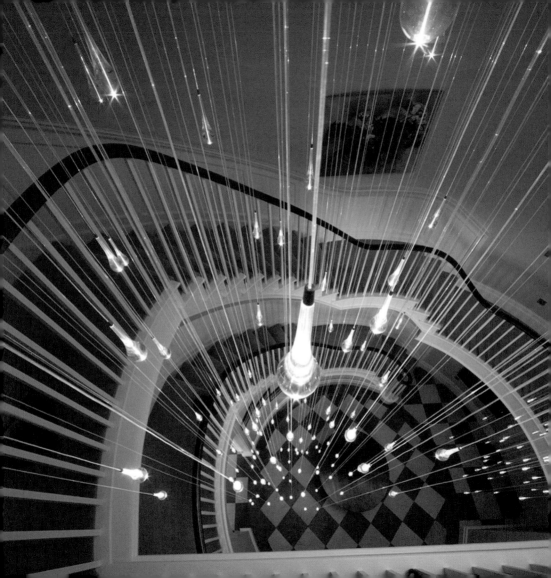

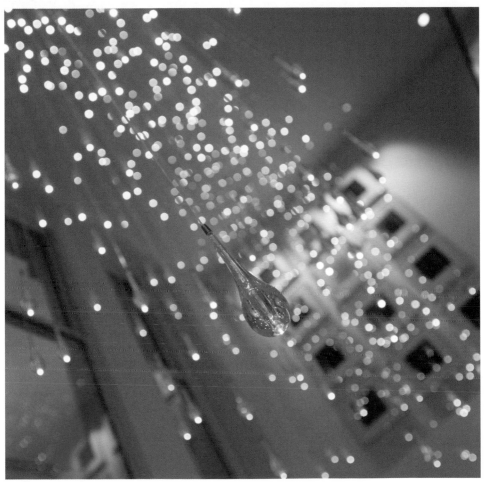

Opposite: Light Shower, *private residence, Somerset, UK, 2012.*
Above: Light Shower, *private residence, London, UK, 2009.*

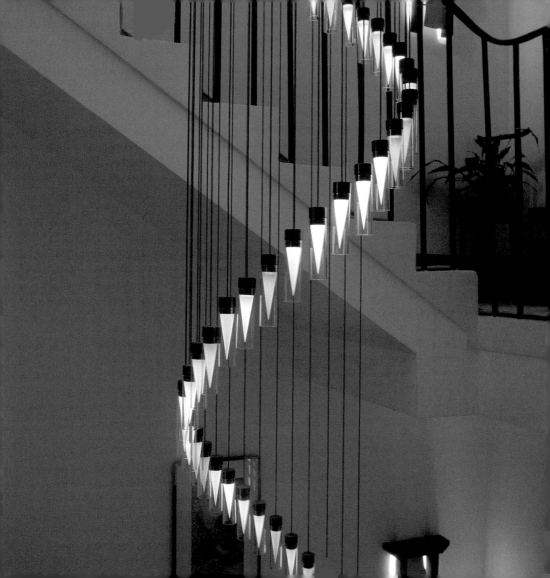

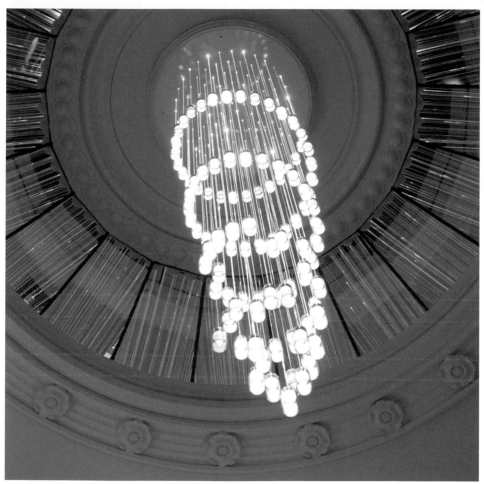

Opposite: Cone Matrix, *private residence, London, UK, 2003.*
Above: Cone Chandelier, *Cotswold House Hotel, Gloucestershire, UK, 2003.*

To my parents, Judy and Brian, and my stepfather, Freddy-Mac—
three guiding lights who allowed me to be.

BIOGRAPHY

British artist Bruce Munro was born in 1959 and completed a B.A. in Fine Arts at Bristol Polytechnic. Shortly thereafter, he moved to Sydney, where he learned about design and lighting, inspired by Australia's natural light and landscape. Returning to Southwest England in 1992, he settled in the countryside.

As a young man, Munro explored several avenues of design and fine art work, finally setting up his own company creating unique lighting and design. Although he has been commissioned for bespoke lighting pieces by corporate clients such as the Royal Institute of Chartered Surveyors, The Royal Society, Liberty & Co., and the W New York Downtown Hotel, his heart lies in creating large-scale art installations, for which he has gained an international reputation. In 2004, he created the first *Field of Light* in the pasture behind his seventeenth-century home, using the help of friends and family. He repeated this in 2010, but with over 600,000 used CDs, for the installation *CDSea*.

His work has been shown at the Victoria & Albert Museum (London), the Biennale Kijkduin (Den Hague), the Eden Project (Cornwall), Kensington Palace (London), and the Guggenheim Museum (New York). In 2010–11, Munro's installations were shown in the thirteenth-century Gothic Salisbury Cathedral and at the Holburne Museum (Bath). In 2012, Munro mounted his first solo exhibition in the United States for Longwood Gardens (Kennett Square, Pennsylvania). The year was rounded off with a UK exhibition at Waddesdon Manor in Buckinghamshire, the beginning of a four-year exhibition residency as part of the Contemporary at Waddesdon programme. The year 2013 saw further solo exhibitions in America at Cheekwood Botanical Garden and Museum of Art (Nashville, Tennessee) and at Franklin Park Conservatory (Columbus, Ohio).

Munro and his wife, Serena, live in Wiltshire, UK, and have four children.

Photographers

Special thanks to Mark Pickthall, who photographed the majority of this book.
Also, thank you to the photographers who contributed:
Vincent Evans, p. 32
Kyle Dreier, p. 16–17
John Griggs, p. 66–67
Hank Davis, p. 75.

Sea Hill Press Inc.
P.O. Box 60301
Santa Barbara, CA 93160
www.seahillpress.com

Library of Congress Control Number: 2013950479
ISBN: 978-1-937720-18-6

Printed in Hong Kong